ANTHONY HEART

Sound Heart

Relational, Biblical & Leadership Skills To Effectively Guide, Develop & Nurture Your Worship Space

Copyright © 2024 by Anthony Heart

All rights reserved. No part of this publication may be reproduced, stored or transmitted in any form or by any means, electronic, mechanical, photocopying, recording, scanning, or otherwise without written permission from the publisher. It is illegal to copy this book, post it to a website, or distribute it by any other means without permission.

Anthony Heart asserts the moral right to be identified as the author of this work.

Anthony Heart has no responsibility for the persistence or accuracy of URLs for external or third-party Internet Websites referred to in this publication and does not guarantee that any content on such Websites is, or will remain, accurate or appropriate.

Designations used by companies to distinguish their products are often claimed as trademarks. All brand names and product names used in this book and on its cover are trade names, service marks, trademarks and registered trademarks of their respective owners. The publishers and the book are not associated with any product or vendor mentioned in this book. None of the companies referenced within the book have endorsed the book.

First edition

This book was professionally typeset on Reedsy. Find out more at reedsy.com

Contents

Introduction	1
1 Dig Deeper: Robust Biblical Foundation	6
2 Have A Heart: Pastoral Care and Servant Leadership	12
3 Dream Team: Team Building and Effective Communication	17
4 Shepard: Cultural Sensitivity and Spiritual Disciplines	22
5 The Fruit: Mentorship, Discipleship, and Community	27
6 Conclusion: A Journey of Growth and Transformation	33
7 Resources	36

Introduction

Whether you're a seasoned worship leader, just stepping into this vibrant role or just want to learn about some of the key components for building a sound heart for worship, this book is for you. We're embarking on a journey to deepen your understanding, strengthen your relationships, and enhance your leadership skills, all through the lens of worship.

Imagine this: the lights are dim, the first chords of a familiar worship song begin to play, and a sense of peace washes over the congregation. As a worship leader, you're not just orchestrating a set of songs; you're guiding people into an encounter with the divine. It's a profound responsibility and a beautiful privilege. But what happens beyond the music? How do you cultivate a worship space that's not only musically excellent but also spiritually vibrant and relationally rich?

I'm thrilled to share this journey with you because I've been where you are. I've felt the weight of leading a team, the joy of seeing hearts transformed, and the challenges that come with nurturing a worship community. This book was born out of my own experiences, struggles, and triumphs. It's a compilation of what I've learned, what I wish I had known earlier, and what I believe will help you thrive in your unique calling.

In the pages ahead, we'll dive into the core aspects that shape a dynamic worship leader. Here's a glimpse of what we'll explore together:

Robust Biblical Foundation: We'll start by grounding ourselves in the Word. A deep understanding of the Bible, especially scriptures related to worship, is essential. You'll learn how theological concepts inform worship practices and why biblical literacy is your most powerful tool. This foundation will help you navigate the complexities of worship leadership with confidence and clarity. We will explore how to apply biblical truths in practical ways, ensuring that every aspect of your worship ministry is rooted in sound doctrine. By developing a robust biblical foundation, you'll be equipped to teach and lead others with integrity and wisdom, fostering a worship environment that is spiritually enriching and theologically sound.

Colossians 3:16 (New International Version, 1978/2011): "Let the message of Christ dwell among you richly as you teach and admonish one another with all wisdom through psalms, hymns, and songs from the Spirit, singing to God with gratitude in your hearts."

Pastoral Care and Servant Leadership: Next, we'll delve into the heart of leadership. You'll discover how to provide spiritual and emotional support to your team and congregation. We'll talk about leading with humility, prioritizing others' needs, and embodying the principles of servant leadership. This section will also cover practical aspects of pastoral care, such as offering effective counseling and being present during times of crisis. You'll learn how to create a culture of care and compassion within your worship team, ensuring that each member knows they are valued and supported. Embracing servant leadership will transform your approach, making you a more effective and empathetic leader who truly reflects the heart of Christ.

Philippians 2:3-4 (New International Version, 1978/2011): "Do nothing out of selfish ambition or vain conceit. Rather, in humility value others above

INTRODUCTION

yourselves, not looking to your own interests but each of you to the interests of the others."

Team Building and Effective Communication: A strong team is the backbone of any worship ministry. We'll discuss strategies for creating a cohesive, supportive environment. You'll learn how to foster collaboration, resolve conflicts, and develop clear, empathetic communication skills. This section will provide tools for building trust and unity among team members, ensuring everyone works together harmoniously. We'll also explore the importance of regular team meetings and transparent communication to keep everyone aligned with the ministry's vision. By mastering these skills, you'll be able to lead a dynamic, motivated worship team that functions smoothly and effectively, enhancing the overall worship experience for your congregation.

Ephesians 4:16 (New International Version, 1978/2011): "From him the whole body, joined and held together by every supporting ligament, grows and builds itself up in love, as each part does its work."

Cultural Sensitivity and Spiritual Disciplines: Worship is diverse and multifaceted. This section will help you understand and respect the diverse backgrounds of your congregation. You'll learn how to integrate various cultural expressions of worship and lead your team and congregation in spiritual disciplines like prayer and fasting. We'll discuss the significance of inclusivity in worship, ensuring that everyone feels represented and valued. Additionally, you'll gain insights into how to encourage and model spiritual disciplines, creating a rhythm of worship that deepens faith and fosters spiritual growth. Embracing cultural sensitivity and spiritual disciplines will enrich your worship services, making them more meaningful and impactful for your diverse congregation.

Revelation 7:9 (New International Version, 1978/2011): "After this I looked, and there before me was a great multitude that no one could count, from every nation, tribe, people and language, standing before the throne and before the Lamb. They were wearing white robes and were holding palm branches in their hands."

Mentorship, Discipleship, and Community Engagement: Finally, we'll focus on growth and community. You'll discover how to mentor and disciple your team members, fostering their spiritual and musical growth. We'll also explore the importance of building strong relationships within the church community and being actively involved in the lives of your congregation members. This section will offer strategies for creating a culture of mentorship, where experienced members guide and support newer ones. We'll also discuss the role of community engagement in strengthening the church body, including practical ways to connect with and serve your congregation. By prioritizing mentorship, discipleship, and community engagement, you'll cultivate a nurturing and vibrant worship environment that encourages continuous growth and deeper connections.

1 Thessalonians 5:11 (New International Version, 1978/2011): "Therefore encourage one another and build each other up, just as in fact you are doing."

By the time you finish this book, you'll have a comprehensive toolkit for effective worship leadership. You'll be equipped to build meaningful relationships, grounded in a robust biblical foundation, and lead your team with confidence and compassion. This holistic approach will transform not only your worship space but the lives of others involved as well as your own personal growth as a leader.

As we embark on this journey, I encourage you to approach each chapter

INTRODUCTION

with an open heart and mind. Reflect on your own experiences, and consider how the principles we discuss can be applied in your context. In the next chapter, we'll lay the foundation by diving into the scriptures. We'll explore the importance of biblical literacy and how a strong theological understanding can transform your worship practices.

Let's get started. Turn the page, and let's begin this transformative journey together.

1

Dig Deeper: Robust Biblical Foundation

Imagine you're preparing for a Sunday service. You've selected the songs, rehearsed with the band, and prayed for a powerful encounter. But beneath the melodies and harmonies lies a deeper layer – a foundation that holds everything together: your understanding of Scripture and theology. This is a vital part of being a leader in ministry whether you're a pastor, worship leader, small group leader, etc. If you're being called to lead a group to Christ, having a firm foundation is a must. Let's explore how a robust biblical foundation transforms worship, guiding you to lead with wisdom and depth.

The Importance of Biblical Literacy

At the heart of worship is the Word of God. It's our source of truth, inspiration, and guidance. But biblical literacy goes beyond knowing verses; it's about understanding context, interpreting meaning, and applying truths to our lives and worship practices. Think of the Bible as a treasure trove, rich with insights that can elevate your worship leading. Each passage, when deeply understood, can transform how we approach worship, making it a more profound and spiritually enriching

experience.

For instance, consider *Psalm 95:1-2 (New International Version, 1978/2011)*: "Come, let us sing for joy to the Lord; let us shout aloud to the Rock of our salvation. Let us come before him with thanksgiving and extol him with music and song." These verses are more than a call to worship; they reflect a posture of gratitude and reverence. They remind us that worship is an act of joy and celebration, rooted in the recognition of God's steadfastness and salvation. When you lead worship with a deep grasp of such scriptures, you invite the congregation into a richer, more meaningful experience.

Understanding the context of these verses is crucial. *Psalm 95* is part of a series of psalms that emphasize the greatness of God as King and Creator. This context highlights the reasons for our joy and thanksgiving—God's sovereignty and his creative power. By conveying this context to your congregation, you help them see beyond the words to the deeper truths of who God is and why we worship him.

Interpreting the meaning of these scriptures involves looking at the original language and cultural background. For example, the Hebrew word for "sing" in *Psalm 95:1*, "ranan," conveys a shout of joy, which adds a layer of intensity and exuberance to the call to worship. Similarly, the term "Rock of our salvation" evokes imagery of stability and protection, reassuring worshipers of God's unchanging nature and His role as our savior.

Another example in *Philippians 4:4 (New International Version, 1978/2011)*: "Rejoice in the Lord always. I will say it again: Rejoice!" The Greek word for "rejoice," "chairo," implies a continuous, deep-seated joy that goes beyond fleeting happiness. This nuance highlights the persistent and

resilient nature of the joy believers are called to embody. Additionally, the phrase "in the Lord always" underscores that this joy is rooted in our relationship with Christ, providing a steady source of comfort and strength. Understanding these aspects enriches our worship by reminding us that our joy is grounded in our unchanging connection with God.

Applying these truths to our worship practices means letting these insights shape our worship services. When leading, you can frame songs and prayers around the themes of joy, gratitude, and reverence. Encourage the congregation to reflect on God's unchanging nature and His mighty acts as reasons for their praise. As *Psalm 100:4 (New International Version, 1978/2011)* says, *"Enter his gates with thanksgiving and his courts with praise; give thanks to him and praise his name."* This approach transforms worship from a routine activity into a dynamic encounter with the divine, grounded in the timeless truths of Scripture.

In essence, biblical literacy empowers you to lead worship that is not just emotionally stirring but theologically sound. It helps you create a worship environment where the congregation can connect deeply with God, understanding more fully the reasons for their praise and worship. By treating the Bible as the rich, multifaceted resource it is, you can guide your worship team and congregation into deeper spiritual maturity and more meaningful worship experiences.

Theological Concepts and Worship Practices

Understanding key theological concepts is equally vital. Theology shapes how we see God, ourselves, and our worship. For example, acknowledging God's sovereignty shifts our focus from performance to genuine worship, recognizing that it's not about us but about honoring

Him. This shift fosters trust and surrender, allowing us to focus fully on His majesty.

Another crucial concept is the Trinity—Father, Son, and Holy Spirit. This three-in-one mystery enriches our worship as we sing to God the Father, celebrate Jesus' redemptive work, and invite the Holy Spirit's presence. It reminds us that worship involves the entire Godhead, deepening our connection with God. Understanding the Incarnation, that God became flesh in Jesus Christ, adds depth to our worship by highlighting God's closeness and sacrificial love. Reflecting on the Incarnation inspires worship that is intimate and awe-inspiring.

The concept of salvation—justification, sanctification, and glorification—reminds us of Christ's ongoing work in our lives. It shifts worship to gratitude and hope, celebrating both what God has done and what He continues to do in and through us.

Incorporating these theological concepts into worship transforms it into a rich, doctrinally sound experience that educates and edifies the congregation, drawing them closer to God's truth.

Practical Steps to Deepen Biblical Literacy

Now, you might wonder, how do I deepen my biblical literacy? Here are some practical steps:

1. **Regular Bible Study:** Set aside dedicated time each day to read and study the Bible. Use study guides, commentaries, and other resources to delve deeper into the text.
2. **Theological Education:** Consider taking courses in theology or attending workshops and seminars. Many churches offer training

programs that can help you grow in your understanding.
3. **Memorization and Meditation:** Memorize key scriptures and meditate on them. Let their truths permeate your mind and heart, shaping your thoughts and actions.
4. **Community Learning:** Join a Bible study group or a theological discussion forum. Learning with others can provide new insights and perspectives.
5. **Prayerful Reflection:** Pray for wisdom and understanding as you study. Ask the Holy Spirit to illuminate the scriptures and reveal deeper meanings.

As you deepen your biblical literacy, it's essential to apply this knowledge to your worship leading. Here are some ways to do that:

- **Song Selection:** Choose songs that are rich in biblical truth. Ensure the lyrics align with scriptural teachings and theological soundness.
- **Scriptural Integration:** Incorporate scripture readings into your worship sets. This could be a passage that complements a song or a verse that sets the theme for the service.
- **Teaching Moments:** Take opportunities to briefly explain the biblical basis of a song or a worship practice. This helps the congregation understand and connect more deeply.
- **Prayer Focus:** Lead prayers that reflect biblical themes and truths. Let scripture guide your intercessions and declarations.

Consider the story of a worship leader named Stacy. Stacy always felt something was missing in her worship sets. After attending a biblical literacy workshop, she began to see the profound impact of scripture on worship. So what does Stacy do? She starts incorporating more Bible

readings and choosing 2, maybe 3 out of the 4 songs for Sunday morning with biblical themes that resonate with the teaching of that morning's service. The change was palpable – the congregation engaged more deeply, and the worship experience became richer and more meaningful.

A robust biblical foundation is not just a theological exercise; it's the bedrock of effective worship leading. It informs your decisions, enriches your worship, and guides your congregation into deeper encounters with God. As you dig deeper into the Word and embrace key theological concepts, you'll find your worship leadership transformed, grounded in truth, and alive with spiritual vitality.

2

Have A Heart: Pastoral Care and Servant Leadership

Picture the weight of a struggling team member's confession or the silent cry of a congregant dealing with loss. As a worship leader, your role extends beyond the music; you're called to shepherd your team and congregation with compassion and humility. The impact of your leadership reaches far into the hearts of those you guide. In this chapter, we'll explore the essence of pastoral care and servant leadership, learning to prioritize others' needs and embody Christ-like principles. You will discover how to provide spiritual and emotional support, offering guidance and prayer, and being present in moments of need. We'll delve into the qualities that define a servant leader, such as humility, empathy, and selflessness, showing how these traits can transform your ministry. By embracing these principles, you'll not only lead effectively but also create a nurturing environment where your team and congregation can grow and flourish spiritually.

Pastoral Care

Pastoral care is the heart of nurturing your team and congregation. It's

about being present, listening, and offering spiritual and emotional support. Here's how you can develop a heart for pastoral care:

1. **Be Present and Available:** Availability is the first step. Make time to connect with your team and congregation outside of rehearsals and services. This could be through regular check-ins, coffee meetings, or simply being approachable after services. Your presence communicates care and builds trust.
2. **Listen Actively:** Listening is more than hearing words; it's about understanding the emotions and needs behind them. Practice active listening by giving your full attention, asking open-ended questions, and responding with empathy. Let people feel heard and valued.
3. **Offer Prayer and Encouragement:** Prayer is a powerful tool for support. Offer to pray with and for your team members and congregants. Share scriptures that speak to their situations, and encourage them with words of hope and faith. Your prayers can bring comfort and strength.
4. **Provide Guidance and Counseling:** Sometimes, pastoral care involves giving advice or counseling. Equip yourself with basic counseling skills, and know when to refer individuals to professional help if needed. Your guidance, rooted in biblical wisdom, can offer clarity and direction.
5. **Create a Safe Environment:** Ensure your worship space is a safe place for vulnerability. Foster an atmosphere where people feel comfortable sharing their struggles and victories. Confidentiality and respect are crucial in building a supportive community.

With all of that said, I believe there's an underlying theme when it comes to putting these ideas into action. One word. Intentional. It's easy to

say these things and offer up an open ear or give guidance to another person just to do it, but being intentional and actually having a heart is where it really matters.

Servant Leadership

Servant leadership is about leading by example with humility and a servant's heart. It's prioritizing the needs of your team and congregation over your own. Here's how you can cultivate servant leadership:

1. **Lead with Humility:** Humility is the cornerstone of servant leadership. Acknowledge that leadership is not about power, but about serving others. Be willing to take on tasks that may seem menial and show that no role is beneath you. Your humility will inspire others. We see this at the core of who Jesus is. He literally came down to earth, got low with us and served in ways that others thought would be beneath the Son of God. True humility at its finest.
2. **Empower and Equip:** A servant leader focuses on empowering others. Identify the strengths and potential in your team members, and provide opportunities for them to grow and shine. Offer training, mentorship, and resources to help them develop their gifts.
3. **Foster a Culture of Service:** Encourage a culture where serving each other is the norm. Model this by serving your team and congregation selflessly. Celebrate acts of service and create opportunities for your team to serve within and outside the church. This could be as simple as getting your team together to volunteer at a food shelter together or going as a group to help someone tidy up their yard, move furniture, etc. Within a community, there's almost always going to be ways you can contribute to help someone

so you might as well do it as a group and set an example of what having a servant heart looks like.

4. **Make Decisions with Others in Mind:** Servant leadership involves making decisions that benefit the collective, not just yourself. Consult your team and consider their input. Show that their voices matter, and make choices that prioritize their well-being and the health of the congregation.

5. **Reflect Christ's Love and Compassion:** Jesus is the ultimate example of a servant leader. Reflect His love and compassion in your actions and attitudes, making His example the foundation of your leadership. Show grace in difficult situations, be patient with those who are struggling, and extend kindness to everyone you lead, regardless of their circumstances. Your leadership should be a living testament to Christ's love, demonstrating humility, empathy, and selflessness. By embodying these qualities, you create a nurturing and supportive environment that encourages spiritual growth and unity within your team and congregation. Let your leadership shine as a beacon of Christ's enduring love and grace.

Pastoral care and servant leadership are not just roles you play; they're ways of living and leading that reflect the heart of Christ. Embracing these principles means embodying the very essence of Jesus' teachings in your everyday interactions. By being present with your team and congregation, listening actively to their needs and concerns, and offering prayer and guidance, you foster a sense of trust and support. Leading with humility and a servant's heart involves putting others before yourself, prioritizing their spiritual and emotional well-being. This approach creates a nurturing worship environment where everyone feels valued and cared for. These principles will not only enhance your leadership capabilities but also build a strong,

compassionate community. By reflecting Christ's love through your actions, you encourage others to do the same, fostering a culture of mutual respect and kindness. Ultimately, pastoral care and servant leadership lay the foundation for a thriving, spiritually vibrant worship community rooted in love and compassion.

3

Dream Team: Team Building and Effective Communication

Dream up a worship team where everyone feels valued, understood, and united in purpose. This is a place where collaboration flows naturally, as team members work together seamlessly towards a common goal. Conflicts, when they arise, are resolved with grace and understanding, strengthening rather than fracturing the group. Communication is clear and empathetic, ensuring that everyone's voice is heard and respected. This chapter is dedicated to building such a dream team, where unity and effectiveness are at the forefront.

We'll dive into strategies that foster collaboration, encouraging each team member to bring their unique gifts and perspectives to the table. By creating an environment where everyone feels included and appreciated, you'll enhance the collective creativity and energy of the group. We'll also look at practical techniques for resolving conflicts, turning potential points of contention into opportunities for growth and deeper understanding.

Developing strong communication skills is another key focus. You'll learn how to facilitate open, honest dialogue, ensuring that feedback is both given and received constructively. Empathetic communication helps to build trust and rapport, making it easier to navigate challenges and celebrate successes together.

Ultimately, this chapter will equip you with the tools and insights needed to cultivate a supportive, harmonious worship team, transforming your worship environment into a space where everyone thrives and the collective mission is joyfully pursued.

Team Building

Creating a cohesive and supportive team starts with intentional team building. Here's how you can cultivate a strong, united worship team:

1. **Foster Collaboration:** Collaboration is the heartbeat of a successful team. Encourage your team members to share their ideas, skills, and perspectives. Create an environment where everyone feels free to contribute, knowing their input is valued. Plan regular team meetings and brainstorming sessions to foster a collaborative spirit. Talk about song suggestions, parts of worship where you can reflect on scripture, flow of songs for service, planning worship nights, etc.
2. **Build Trust:** Trust is the foundation of any strong team. Build trust by being transparent, reliable, and consistent. Follow through on your commitments, and encourage your team to do the same. Celebrate successes together and support each other through challenges.
3. **Define Roles and Expectations:** Clarity is key in team building. Clearly define each team member's role and responsibilities.

Ensure everyone understands what is expected of them and how their contributions fit into the bigger picture. This clarity helps prevent misunderstandings and promotes accountability.

4. **Encourage Personal and Spiritual Growth:** Invest in the growth of your team members. Offer opportunities for skill development and spiritual growth, such as workshops, retreats, and mentorship programs. Encourage them to pursue their passions and develop their talents, both musically and spiritually.
5. **Create a Positive Team Culture:** Cultivate a positive and supportive team culture. Encourage positivity, gratitude, and mutual respect. Celebrate achievements, both big and small, and create an atmosphere where team members feel appreciated and motivated.

Effective Communication

Having functional communication is the glue that holds a team together. Here's how to develop clear, empathetic communication skills within your worship team:

1. **Develop Empathetic Listening:** Empathetic listening is about truly understanding and valuing what others are saying. Practice listening without interrupting, and reflect back what you've heard to ensure understanding. Show empathy by acknowledging their feelings and perspectives.
2. **Facilitate Open Dialogue:** Encourage open and honest communication within your team. Create a safe space where team members feel comfortable expressing their thoughts and concerns. Use regular check-ins and feedback sessions to maintain open lines of communication.

3. **Use Clear and Concise Language:** Clear communication prevents misunderstandings. Be direct and specific in your instructions and feedback. Avoid jargon and overly complex language. Ensure that everyone understands the message and its implications.
4. **Address Conflicts Proactively:** Conflicts are inevitable, but how you handle them makes all the difference. Address conflicts as soon as they arise, before they escalate. Use conflict resolution techniques such as active listening, empathy, and compromise to find solutions that satisfy all parties involved.
5. **Encourage Constructive Feedback:** Constructive feedback is essential for growth. Encourage your team to give and receive feedback in a positive and respectful manner. Focus on specific behaviors and outcomes, rather than personal attributes, and provide actionable suggestions for improvement.

Let's look at Emily, a worship leader who transformed her team through intentional team building and effective communication. By fostering a collaborative environment, she encouraged her team to share their ideas and talents. Emily built trust by being transparent and consistent, and she defined clear roles and expectations for everyone. She invested in their growth through workshops and mentorship, creating a positive team culture.When it came to communication, Emily practiced empathetic listening and facilitated open dialogue during team meetings. She used clear and concise language, ensuring everyone understood their tasks. When conflicts arose, Emily addressed them proactively, using active listening and compromise to resolve issues. Her approach to constructive feedback helped her team members grow and improve continuously.

DREAM TEAM: TEAM BUILDING AND EFFECTIVE COMMUNICATION

Building a dream team requires intentional effort in team building and effective communication. By fostering collaboration, building trust, defining roles, encouraging growth, and creating a positive culture, you lay the foundation for a united and supportive team. Developing clear and empathetic communication skills ensures open dialogue, mutual understanding, and effective conflict resolution.

4

Shepard: Cultural Sensitivity and Spiritual Disciplines

Take a worship environment where every cultural expression is honored and celebrated, and where spiritual practices deepen everyone's connection to God. As a worship leader, you have the privilege of fostering such an inclusive and spiritually vibrant community. This chapter will guide you in respecting diverse cultural expressions and integrating them into worship. Additionally, you'll learn how to lead your team and congregation in spiritual disciplines that nurture their faith and spiritual growth.

Cultural Sensitivity

Embracing cultural diversity within your worship environment enriches the worship experience by bringing a multitude of perspectives and traditions, creating a more vibrant and inclusive atmosphere that honors God's creativity and the beautiful diversity of His creation. Here's how you can put this into practice:

1. **Acknowledge and Respect Diversity:** Start by recognizing the

diverse backgrounds within your congregation. Take time to learn about different cultural traditions and expressions of worship. Show respect for these differences, and demonstrate a willingness to incorporate them into your worship practices.
2. **Integrate Diverse Expressions:** Incorporate diverse cultural expressions into your worship sets. This could include songs from different cultural backgrounds, using various musical styles, and incorporating elements like dance, art, and spoken word that reflect different traditions. Doing so creates a more inclusive environment where everyone feels represented and valued.
3. **Educate and Involve Your Team:** Educate your team about the importance of cultural sensitivity and the value of diverse expressions in worship. Encourage them to bring their cultural backgrounds and ideas into the worship planning process. This involvement fosters a sense of ownership and inclusivity within the team.
4. **Create Opportunities for Cultural Exchange:** Host events or workshops that celebrate different cultures within your congregation. These can be opportunities for cultural exchange, where people share their traditions and learn from each other. Such events build community and deepen mutual understanding.
5. **Be Mindful of Language and Representation:** Be conscious of the language and imagery used in your worship services. Ensure that they are inclusive and representative of the diverse congregation. This mindfulness extends to the lyrics of songs, visuals, and the way you address the congregation.

Spiritual Disciplines

Leading your team and congregation in spiritual disciplines is essential

for fostering a spiritually vibrant community. Here's how you can encourage and practice spiritual disciplines:

1. **Lead by Example:** As a worship leader, your personal practice of spiritual disciplines sets the tone for others. Make prayer, fasting, and meditation integral parts of your life. Share your experiences and the impact these practices have on your spiritual growth.
2. **Incorporate Prayer in Worship:** Make prayer a central element of your worship services. Include times for corporate prayer, intercessory prayer, and personal reflection. Encourage your team and congregation to engage in different forms of prayer, such as thanksgiving, supplication, and contemplation.
3. **Promote Fasting:** Teach about the spiritual benefits of fasting and how it can deepen one's relationship with God. Encourage your team and congregation to practice fasting, whether it's from food, social media, or other distractions. Provide guidance and support, especially for those new to fasting.
4. **Facilitate Meditation on Scripture:** Guide your team and congregation in meditating on Scripture. This could be through structured Bible study sessions, reflective readings during worship, or personal meditation practices. Encourage them to let God's Word dwell richly in their hearts and minds.
5. **Create a Culture of Spiritual Growth:** Foster an environment where spiritual growth is prioritized. Offer resources, such as books, devotionals, and study guides, that help individuals deepen their spiritual practices. Encourage accountability through small groups or prayer partners, and celebrate spiritual milestones together.

Alex is a worship leader in a multicultural church. Alex made it a

point to learn about the different cultures within his congregation and integrated diverse musical styles and languages into the worship services. He also led his team in regular times of prayer and fasting, sharing his experiences and encouraging them to adopt these practices. The result was a worship environment where everyone felt included and spiritually nurtured, and the congregation grew closer to God and each other.

Embracing cultural sensitivity and spiritual disciplines transforms your worship environment into an inclusive and spiritually vibrant community. By acknowledging and integrating diverse cultural expressions, you create a worship space where everyone feels valued and represented, celebrating the unique backgrounds and traditions that each individual brings. This inclusivity fosters a sense of belonging and unity, enriching the worship experience for all.

Leading your team and congregation in practices such as prayer, fasting, and meditation fosters a deeper connection with God and promotes spiritual growth. These disciplines encourage personal reflection and communal bonding, helping individuals to center their lives around God's presence and teachings. When you guide your team in these spiritual practices, you cultivate an environment where faith is actively nurtured and expressed, both personally and collectively.

Moreover, incorporating diverse cultural expressions and spiritual disciplines helps break down barriers, creating a worship experience that is both dynamic and reflective of the global body of Christ. It encourages openness and learning, allowing your congregation to experience the breadth and depth of Christian worship traditions. This holistic approach not only enhances the worship experience but also deepens the spiritual journey of each participant, leading to a more

engaged, spiritually mature, and unified congregation.

5

The Fruit: Mentorship, Discipleship, and Community

Visualize a worship environment where every team member is nurtured, guided, and equipped to grow both spiritually and musically. Envision a church community where relationships are deep, supportive, and centered on Christ's teachings. In this chapter, we will look into the essential roles of mentorship, discipleship, and community engagement. You will discover how to invest in your team's development, fostering their talents and faith journey. By focusing on mentorship, you'll learn effective ways to guide your team members, helping them to unlock their full potential and flourish in their roles.

We'll also explore the principles of discipleship, understanding how to lead others in their spiritual walk, providing them with the tools and encouragement they need to grow closer to God. Discipleship is about more than just teaching; it's about walking alongside others, sharing experiences, and offering continuous support. As *Proverbs 27:17 (New International Version, 1978/2011)* says, *"As iron sharpens iron, so one person sharpens another."* This verse highlights the mutual growth and support that is central to true discipleship.

Additionally, we'll look at the importance of community engagement, emphasizing the value of building strong, meaningful relationships within your church. You'll learn how to create a supportive network where members feel connected, valued, and loved. This chapter will equip you with strategies to cultivate a nurturing and Christ-centered community, where everyone is empowered to grow in their faith and contribute to the collective mission of the church. By investing in these areas, you'll transform your worship environment into a place of growth, unity, and spiritual vibrancy, creating a lasting impact on both your team and the broader church community.

Mentorship

Mentorship is about investing in the growth and development of your team members. Here's how you can be an effective mentor:

1. **Provide Spiritual Guidance:** Guide your team members in their spiritual journeys. Share your own experiences, offer biblical insights, and pray with them. Help them navigate their faith, encouraging them to deepen their relationship with God through reflection and prayer.
2. **Encourage Musical Growth:** Support your team members in honing their musical skills. Provide opportunities for training and practice, and offer constructive feedback. Encourage them to explore and develop their musical talents, using them to glorify God and enhance worship.
3. **Be Available and Approachable:** Make yourself available to your team members. Be approachable and open to their questions and concerns. Show genuine interest in their lives and be willing to walk alongside them through both challenges and triumphs, providing unwavering support.

4. **Set Clear Goals and Expectations:** Help your team members set clear, achievable goals for their spiritual and musical growth. Provide guidance and support as they work towards these goals, and celebrate their progress along the way, fostering a sense of accomplishment and motivation.
5. **Foster a Culture of Mentorship:** Encourage a culture of mentorship within your team. Teach experienced members to mentor others, creating a cycle of growth and support. This culture fosters unity and helps everyone feel valued and invested in, promoting a cohesive team dynamic.

Discipleship

Discipleship, intertwined with mentorship, focuses on spiritual growth and maturity. Here's how to disciple your team and congregation:

1. **Teach and Model Christlike Behavior:** Lead by example, demonstrating Christlike behavior in your actions and interactions. Teach biblical principles and encourage your team and congregation to live out their faith in their daily lives, fostering a community rooted in love and grace.
2. **Facilitate Small Groups:** Organize small groups for Bible study, prayer, and fellowship. These groups provide a space for deeper connection and spiritual growth, fostering accountability and creating a sense of community where members support and uplift one another.
3. **Offer Discipleship Programs:** Develop structured discipleship programs that guide individuals through their spiritual journey. These programs can include Bible study guides, devotional materials, and opportunities for service and outreach, promoting

continuous spiritual development.
4. **Encourage Accountability:** Encourage team members and congregation members to find accountability partners. These relationships provide support, encouragement, and challenge individuals to grow in their faith, ensuring they remain steadfast in their spiritual journey.
5. **Promote Lifelong Learning:** Foster a mindset of lifelong learning. Encourage your team and congregation to continually seek knowledge and understanding of God's Word. Provide resources and opportunities for ongoing education and spiritual development, ensuring sustained growth.

Community Engagement

Building strong relationships within the church community enhances trust, support, and relational depth. Here's how to engage with your community effectively:

1. **Be Approachable and Involved:** Make an effort to be approachable and involved in the lives of your congregation members. Attend church events, participate in community activities, and be present in everyday interactions, showing genuine care and interest in their lives.
2. **Foster a Welcoming Environment:** Create a welcoming and inclusive environment where everyone feels valued and accepted. Encourage your team and congregation to reach out to newcomers and build relationships with those who may feel isolated, ensuring everyone feels part of the community.
3. **Serve the Community:** Engage in community service projects and outreach programs. Encourage your team and congregation

THE FRUIT: MENTORSHIP, DISCIPLESHIP, AND COMMUNITY

to serve others, demonstrating Christ's love through their actions. This service fosters unity and strengthens relationships within the community, promoting a spirit of generosity.

4. **Build Strong Relationships:** Take time to build strong, meaningful relationships within your church community. Be intentional about connecting with others, listening to their stories, and sharing your own. These relationships provide a foundation of trust and support, essential for a thriving community.
5. **Celebrate Together:** Celebrate milestones, achievements, and special occasions together as a community. These celebrations build camaraderie and create lasting memories, reminding everyone of the importance of unity and togetherness in the body of Christ.

Consider Jordan, a worship leader who prioritized mentorship, discipleship, and community engagement. Jordan dedicated time to mentor his team members, offering both spiritual guidance and musical training. He organized small groups and discipleship programs, which significantly helped his team and congregation grow in their faith. Being approachable and actively involved in the lives of his congregation, Jordan built strong, supportive relationships. Through community service and celebratory events, he fostered a sense of unity and togetherness, creating a vibrant, Christ-centered worship environment.

Mentorship, discipleship, and community engagement are essential for nurturing a thriving worship environment. By investing in the growth of your team members and building strong relationships within your church community, you create a supportive, Christ-centered environment where everyone can flourish. This approach not only enhances worship but also strengthens the entire church body, fostering

a community deeply rooted in faith and love.

6

Conclusion: A Journey of Growth and Transformation

As we reach the conclusion of our journey together, it's important to reflect on the key principles we've explored. Leading a worship space is about more than just the music; it's about cultivating a deep, spiritually vibrant community that honors God and supports each other.

In Chapter 1: Dig Deeper: Robust Biblical Foundation, we dived into the significance of a strong biblical literacy and understanding of key theological concepts. A robust biblical foundation enables you to make informed, spiritually grounded decisions in your worship practices.

In Chapter 2: Have A Heart: Pastoral Care and Servant Leadership, we discussed the importance of providing spiritual and emotional support to your team and congregation. Leading with compassion and humility, prioritizing the needs of others, and offering prayer and counseling are fundamental aspects of effective leadership.

Chapter 3: Dream Team: Team Building and Effective Communication

highlighted strategies for creating a united and supportive worship team. Fostering collaboration, resolving conflicts, and developing clear, empathetic communication skills are essential for ensuring open dialogue and mutual understanding.

In Chapter 4: Shepard: Cultural Sensitivity and Spiritual Disciplines, we learned how to respect and integrate diverse cultural expressions in worship. Leading your team and congregation in prayer, fasting, and meditation fosters a lifestyle of personal and corporate spiritual disciplines, creating an inclusive and spiritually rich environment.

Finally, in Chapter 5: The Fruit: Mentorship, Discipleship, and Community, we emphasized the importance of nurturing growth through mentorship and discipleship. Building strong relationships within the church community, being approachable, and engaging with the lives of congregation members enhances relational depth and trust.

As we wrap up, remember that your role as a worship leader is a continuous journey of growth and transformation. Embrace these principles, apply them in your worship environment, and watch as your team and congregation flourish.

Your feedback is invaluable. If you've found this book helpful, I encourage you to leave a review on Amazon. Your insights will not only help others discover this book but also contribute to the ongoing conversation about effective worship leadership.

Thank you for joining me on this journey. May your worship space be a place of profound connection, growth, and spiritual renewal.

CONCLUSION: A JOURNEY OF GROWTH AND TRANSFORMATION

With heartfelt gratitude and blessings,

- A. ♥.

7

Resources

New International Version Bible. (2011). Zondervan. (Original work published 1978)

OpenAI. (2024). ChatGPT (July 2024 version) [Large language model]. Retrieved from https://www.openai.com/chatgpt